IRVING THE DUCK IN THE TORTOISE SHELL SUIT

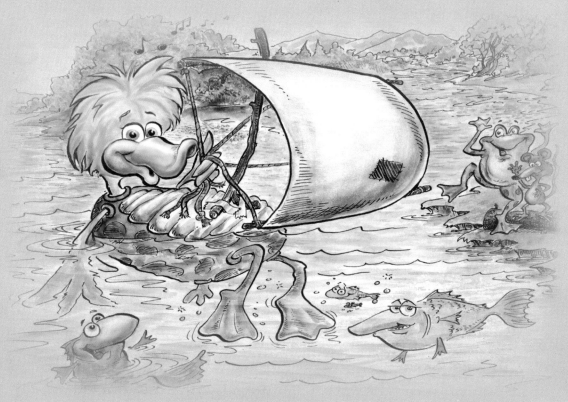

by

Richard Scott Morris

AuthorHouse™
1663 Liberty Drive, Suite 200
Bloomington, IN 47403
www.authorhouse.com
Phone: 1-800-839-8640

First published by AuthorHouse 3/17/2009

ISBN: 978-1-4389-5356-4 (sc)

Printed in the United States of America
Bloomington, Indiana

This book is printed on acid-free paper.

For my father,
Teddy Joseph Morris

He always told me to
"Hold on tight to the
child within you, son."

authorHOUSE®

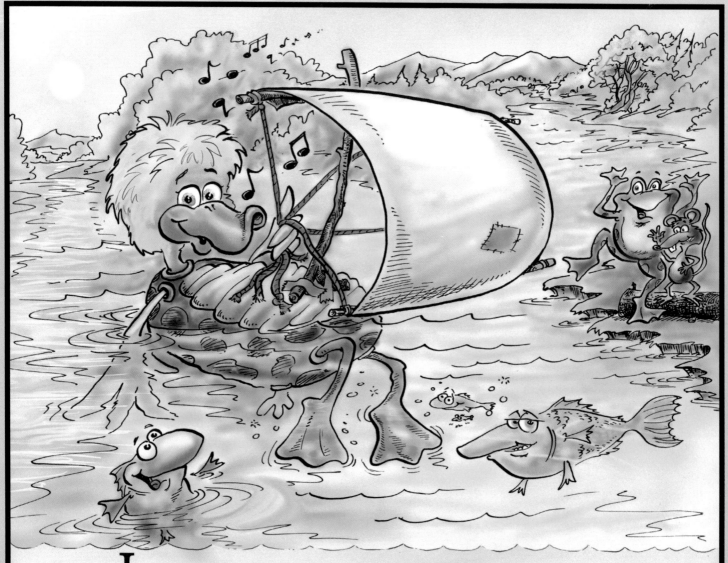

Irving the duck in the tortoise shell suit, swam whistling by with a sweet tune to toot.

He swam and he paddled his webbed little feet as he sailed on upstream using Momma's lost sheet.

Today was a good one. Today was just fine. It seemed long ago... that day when he whined...

"I'm ugly and dumb...
and I'll never learn how...
to be like the big ducks...
I swim like a cow !"

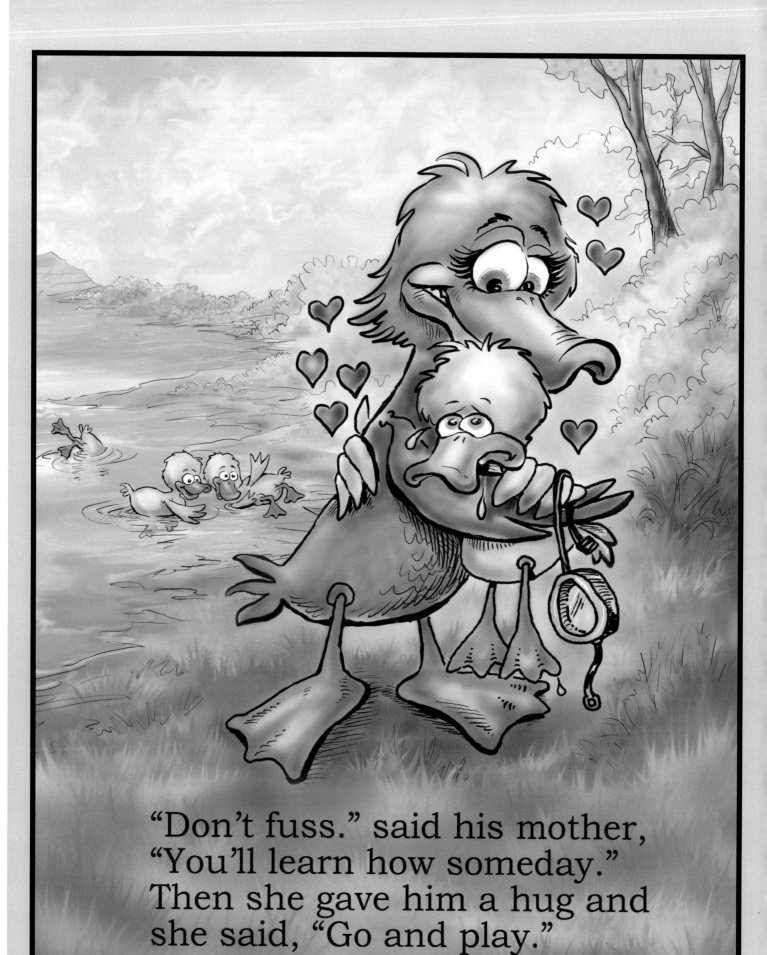

"Don't fuss." said his mother, "You'll learn how someday." Then she gave him a hug and she said, "Go and play."

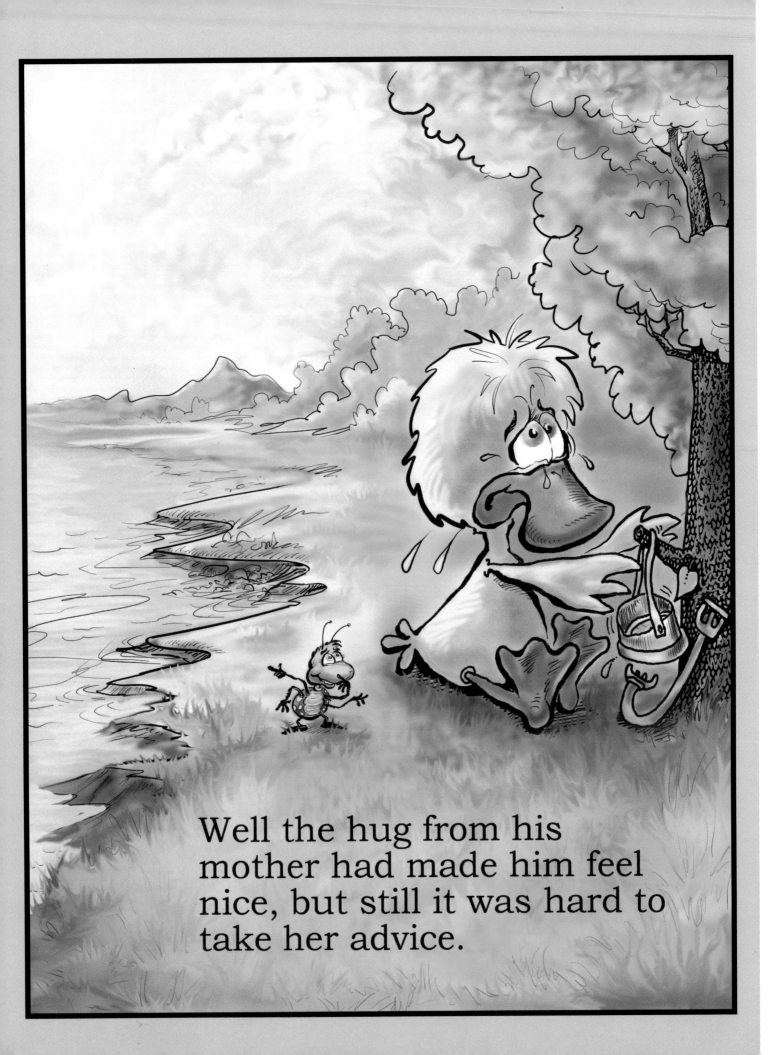

Well the hug from his
mother had made him feel
nice, but still it was hard to
take her advice.

So Irving walked off
toward the forest...real slow.
And he walked pretty far
since his head was hung low.

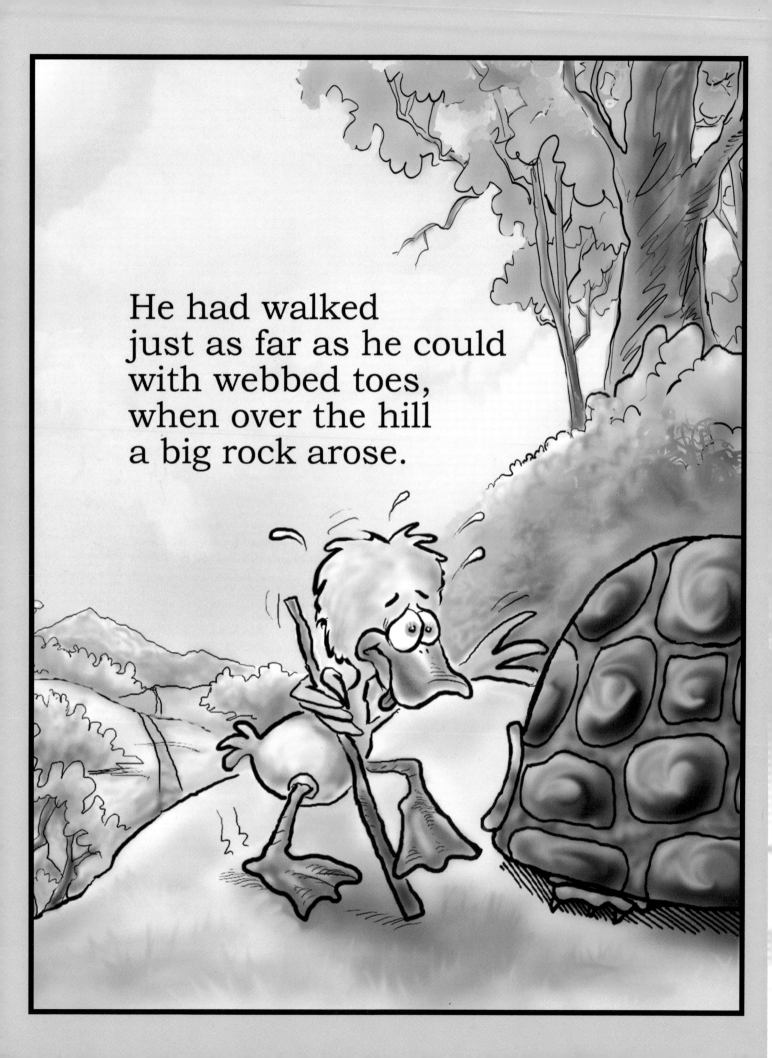

He had walked
just as far as he could
with webbed toes,
when over the hill
a big rock arose.

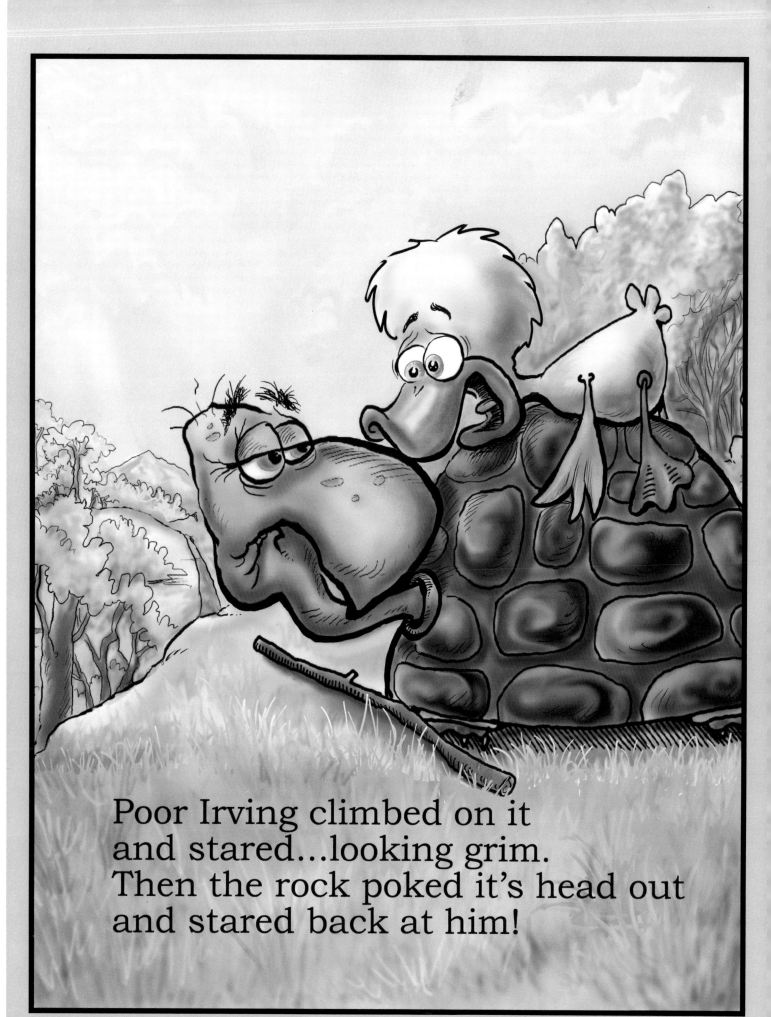

Poor Irving climbed on it
and stared...looking grim.
Then the rock poked it's head out
and stared back at him!

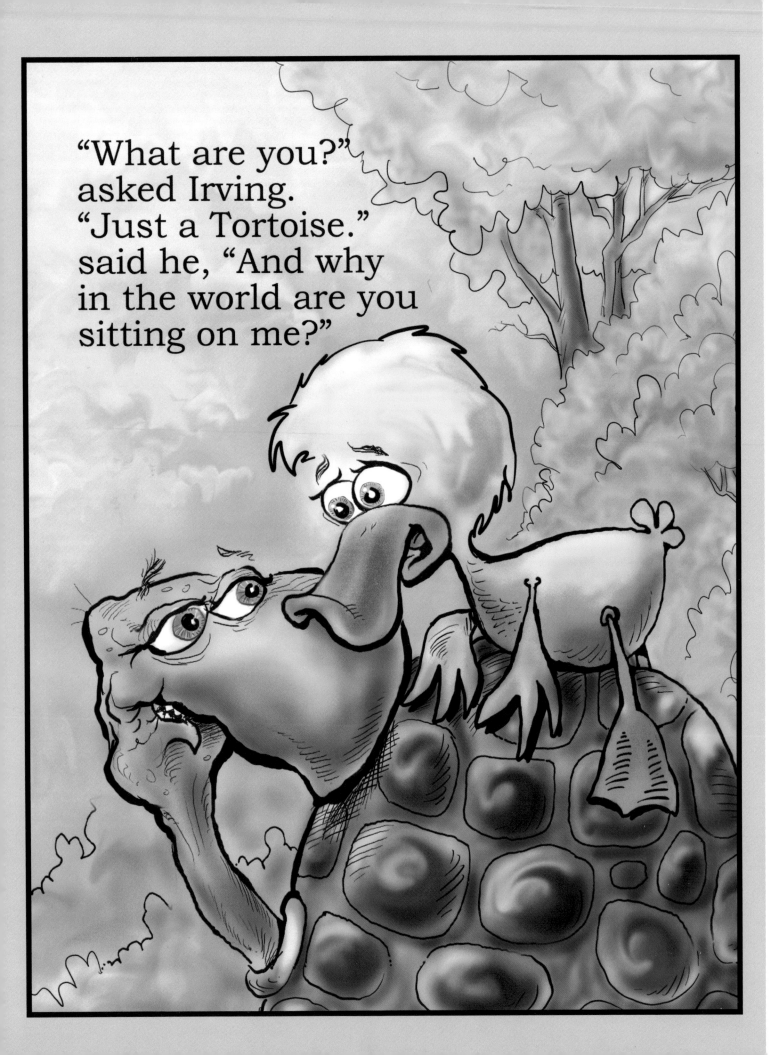

"What are you?" asked Irving. "Just a Tortoise." said he, "And why in the world are you sitting on me?"

"Oh I'm sorry!" quacked Irving
as he jumped to his feet.
"But you are the last thing
I thought I would meet."

"What is wrong?"
asked the Tortoise.

"My life."
said the duck,
"I was walking
and thinking
of all my
bad luck."

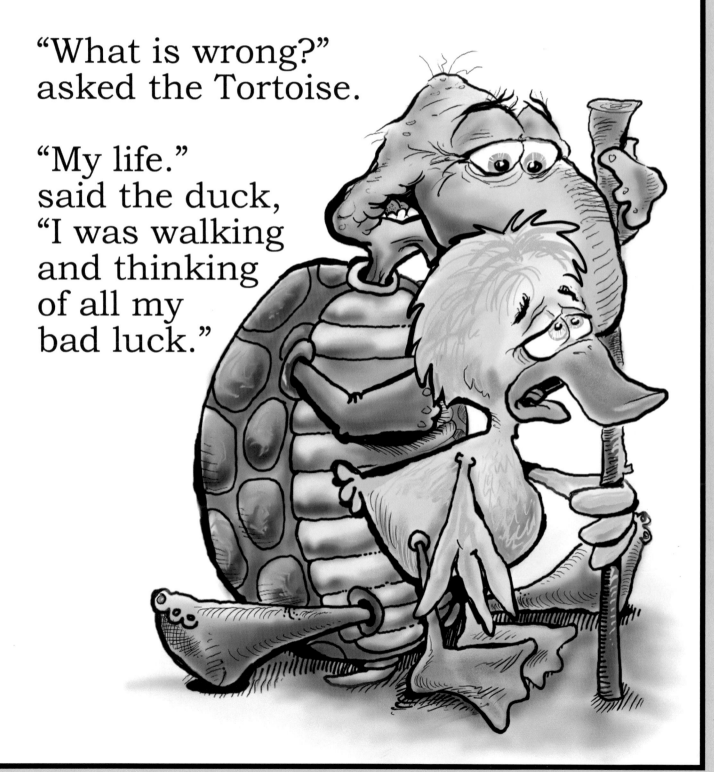

"Bad luck," stated Tortoise,
"is created up here..."
and he tapped on his head
and he said,
"Have no fear."

"If you watch where you're going,
you will know where you've been...
if you don't you will mess up
all over again!"

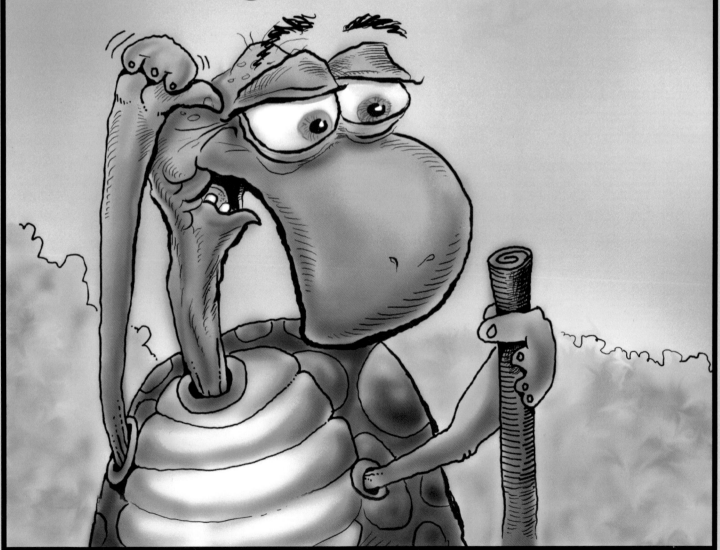

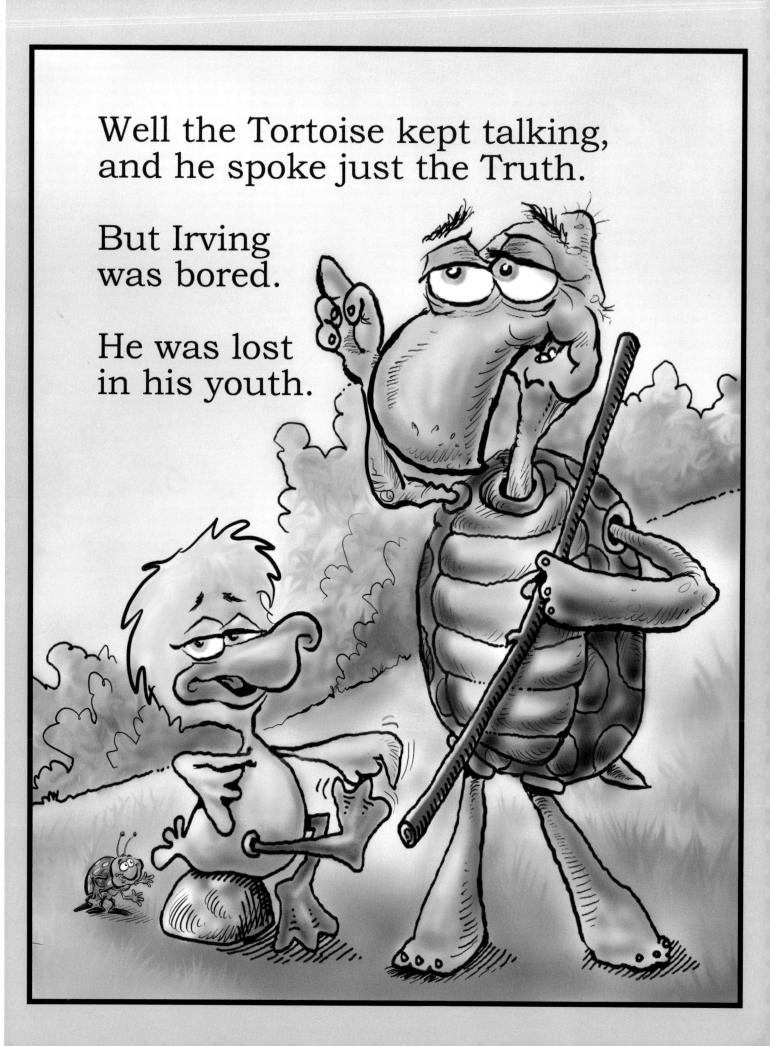

Well the Tortoise kept talking,
and he spoke just the Truth.

But Irving
was bored.

He was lost
in his youth.

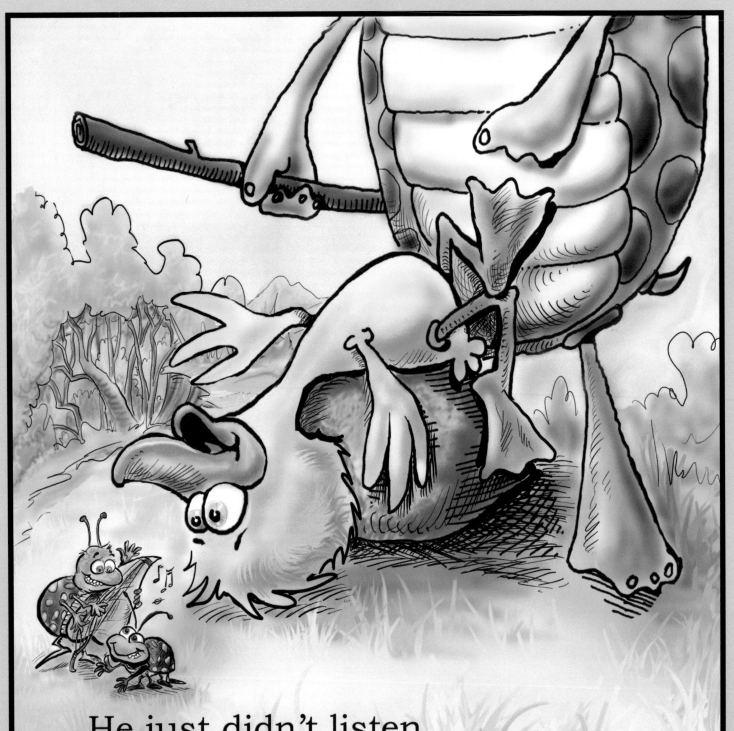

He just didn't listen
to what Tortoise said.

The wisdom it seemed,
wouldn't sink through his head.

As he looked
back at Tortoise,
he noticed
the shell.
It was polished
all over and fit
him quite well.

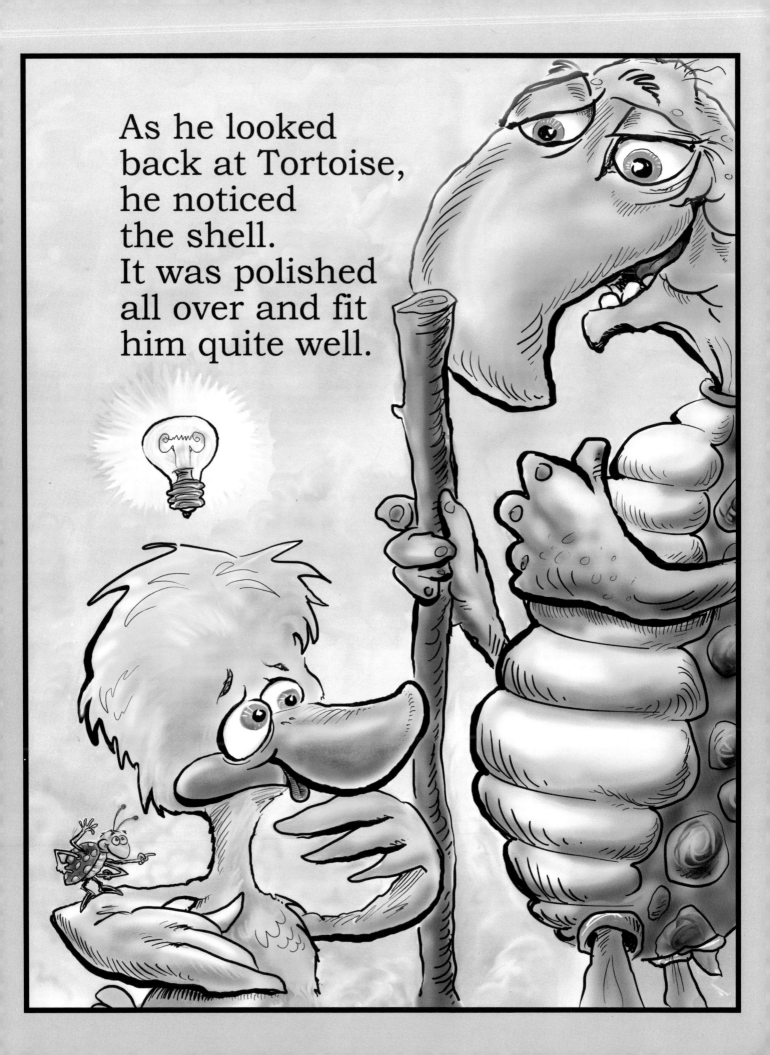

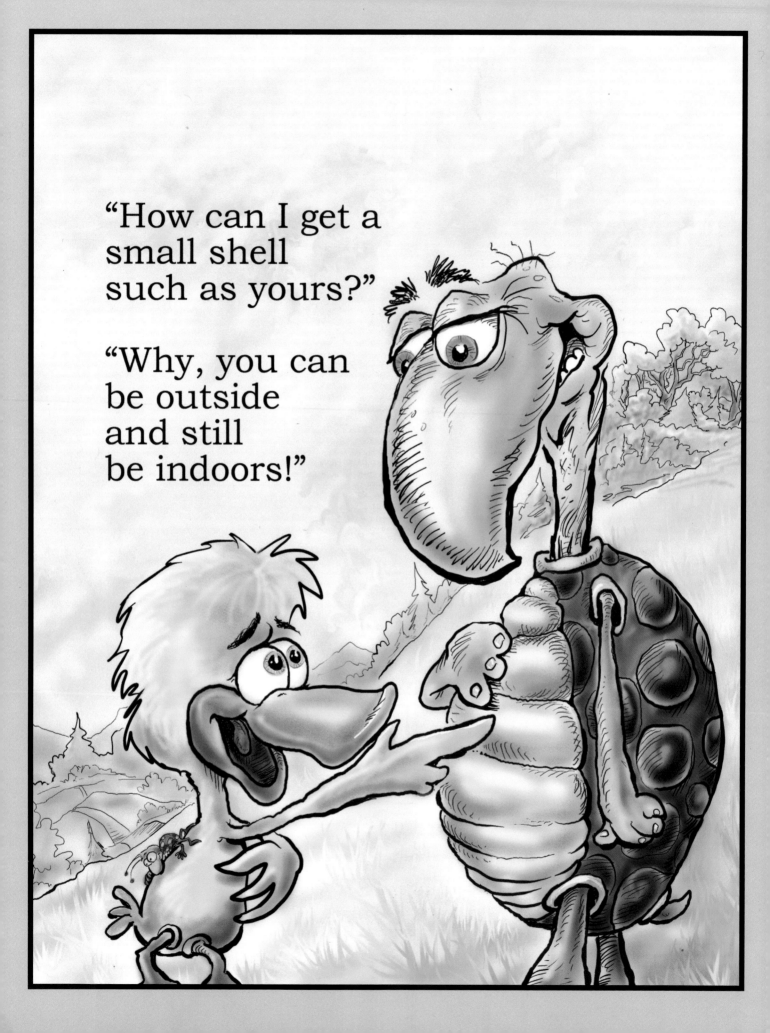

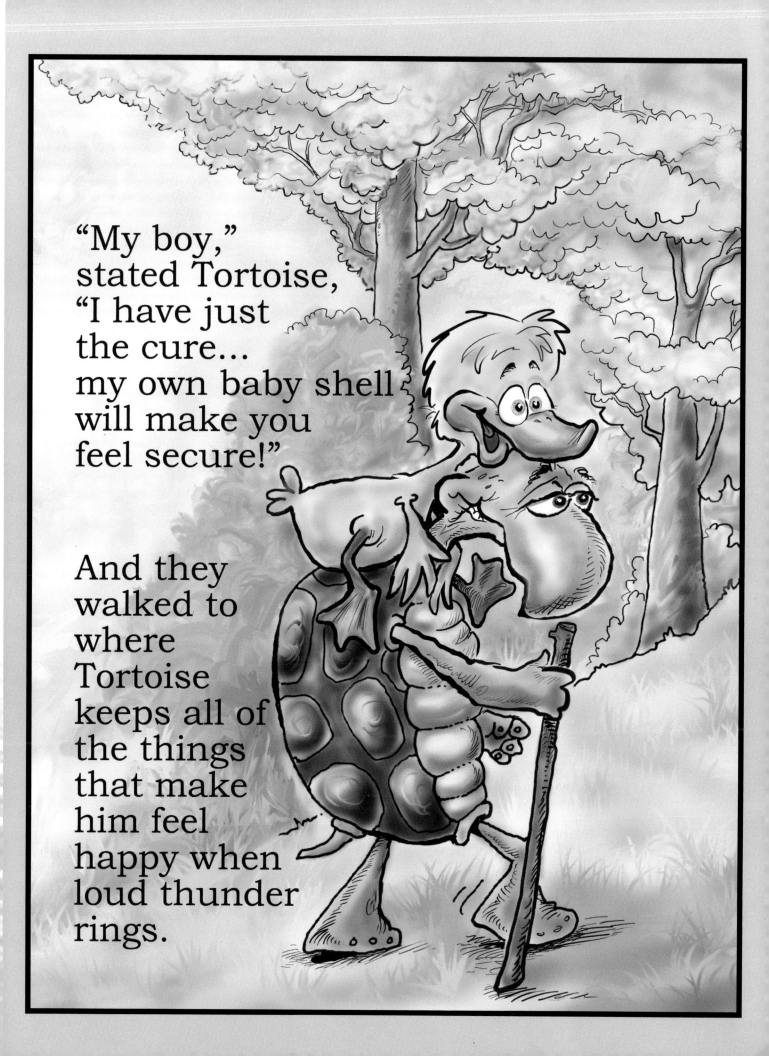

Tortoise went to his closet and opened the door... and there on a hanger, a shell marked size four!

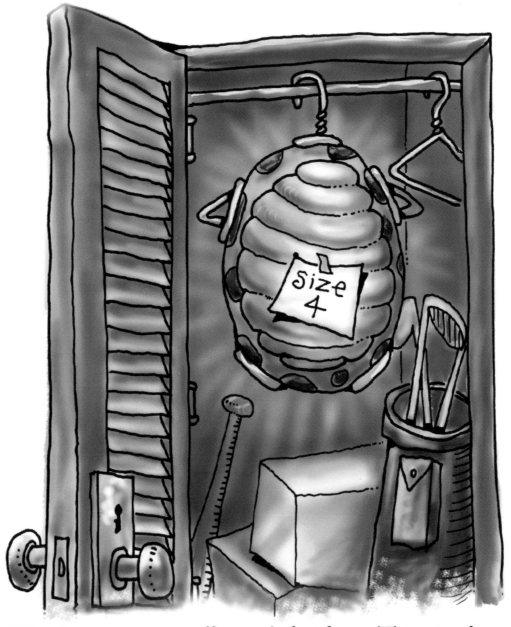

"It is yours." said the Tortoise with a wry little smile. "I'm afraid it's quite dusty and a bit out of style."

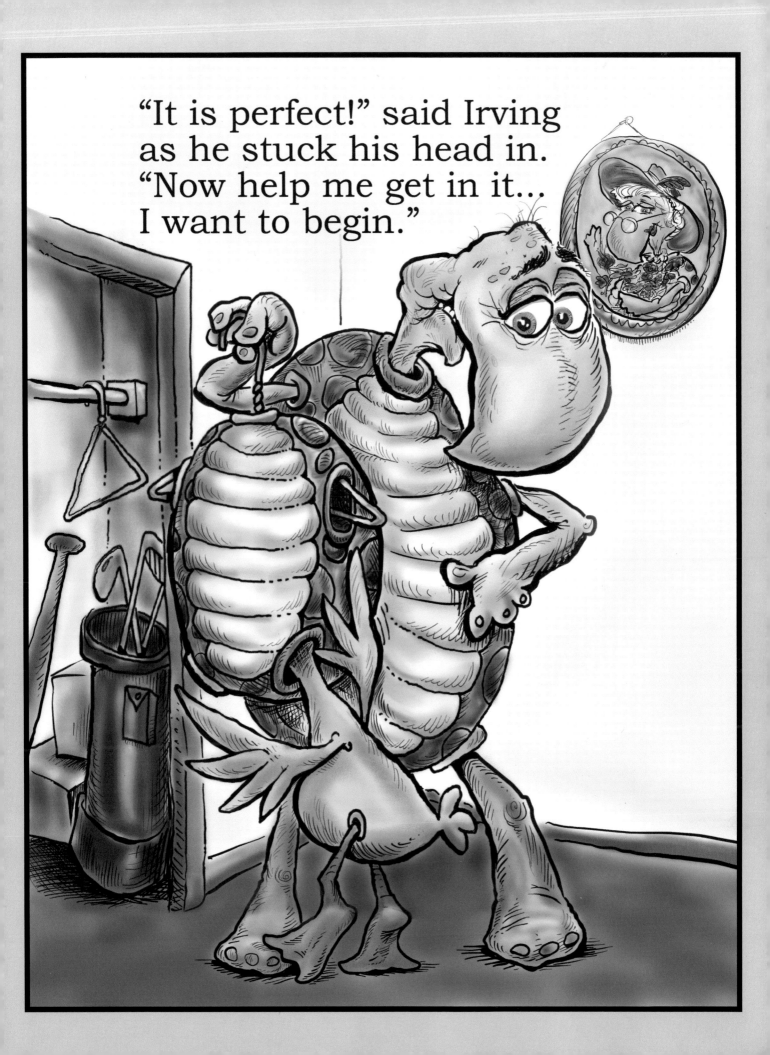

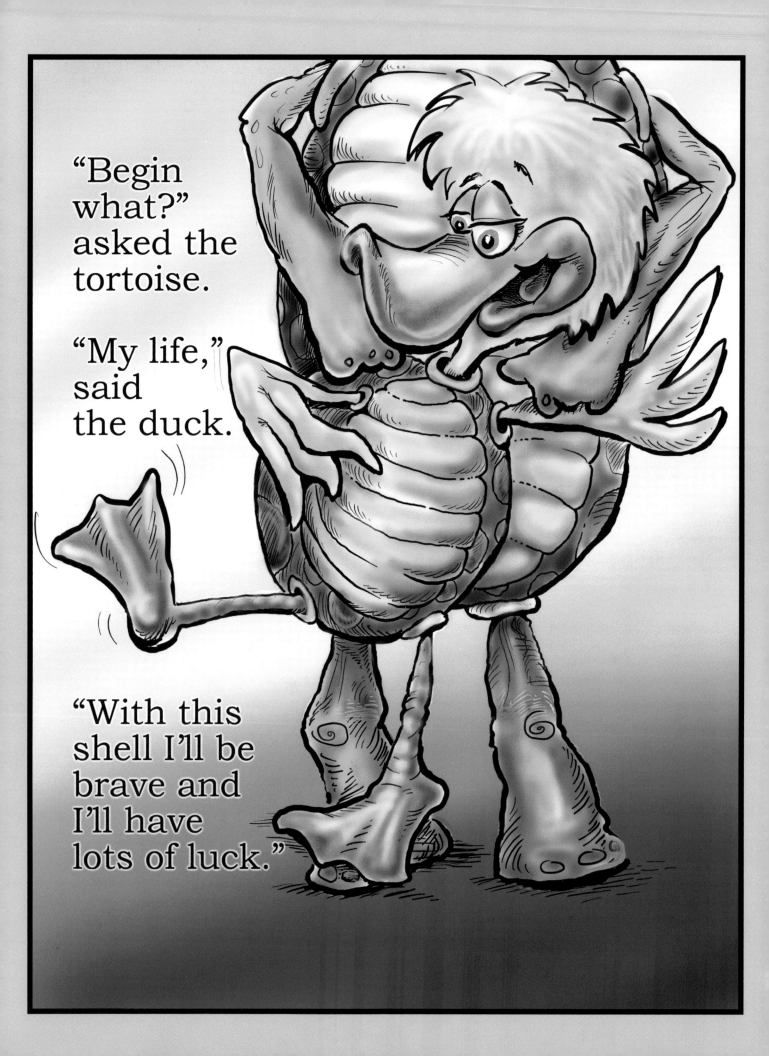

"Thank you much." Irving said as he waved from the door. "Thanks to you and this shell, I will mess up no more."

"We shall see…" said the tortoise in an all knowing way. Then he waved bye to Irving and then bid him "good-day."

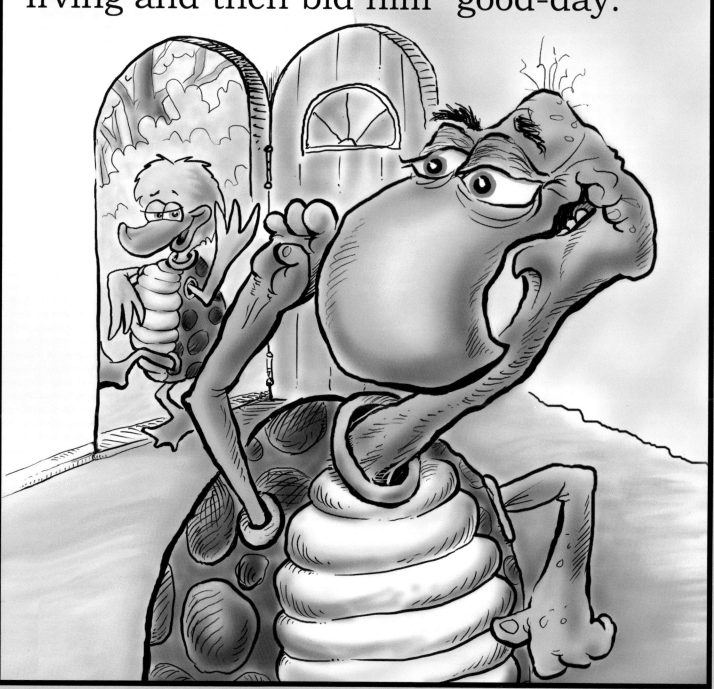

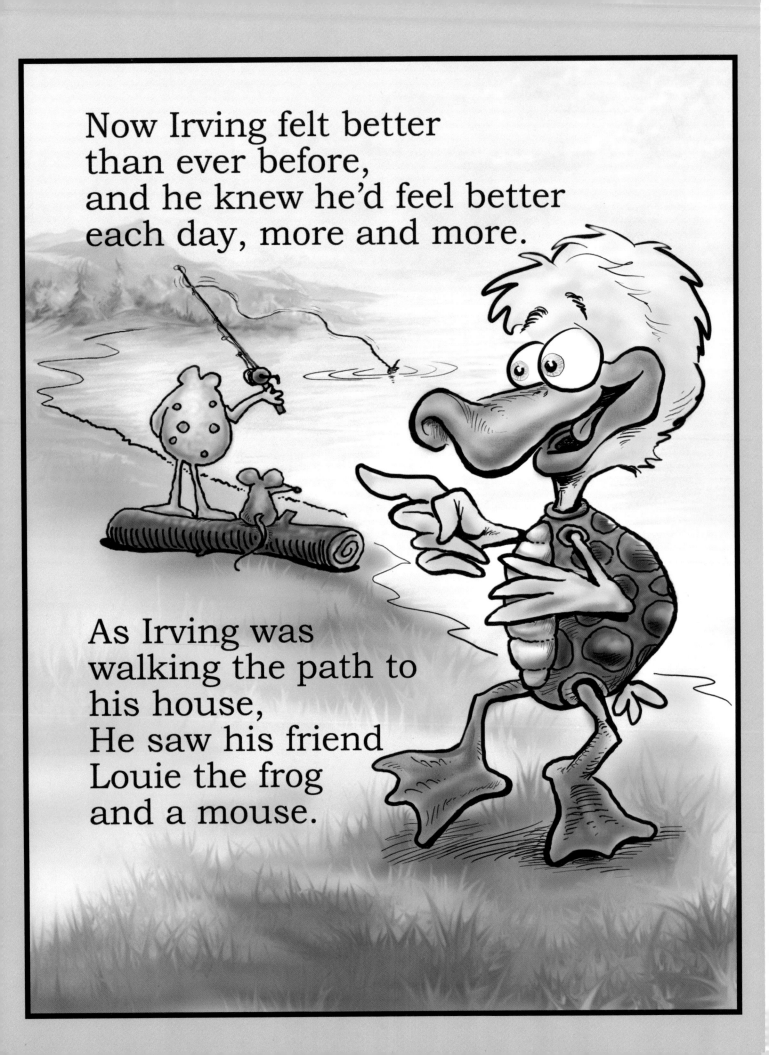

Now Irving felt better
than ever before,
and he knew he'd feel better
each day, more and more.

As Irving was
walking the path to
his house,
He saw his friend
Louie the frog
and a mouse.

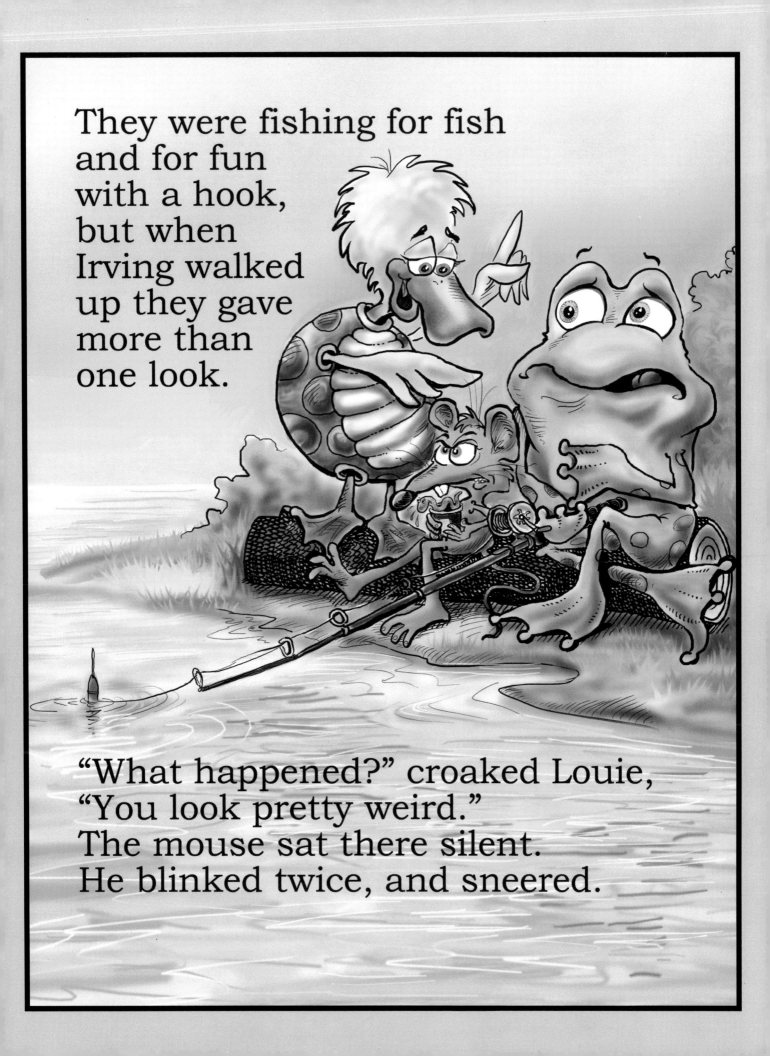

They were fishing for fish
and for fun
with a hook,
but when
Irving walked
up they gave
more than
one look.

"What happened?" croaked Louie,
"You look pretty weird."
The mouse sat there silent.
He blinked twice, and sneered.

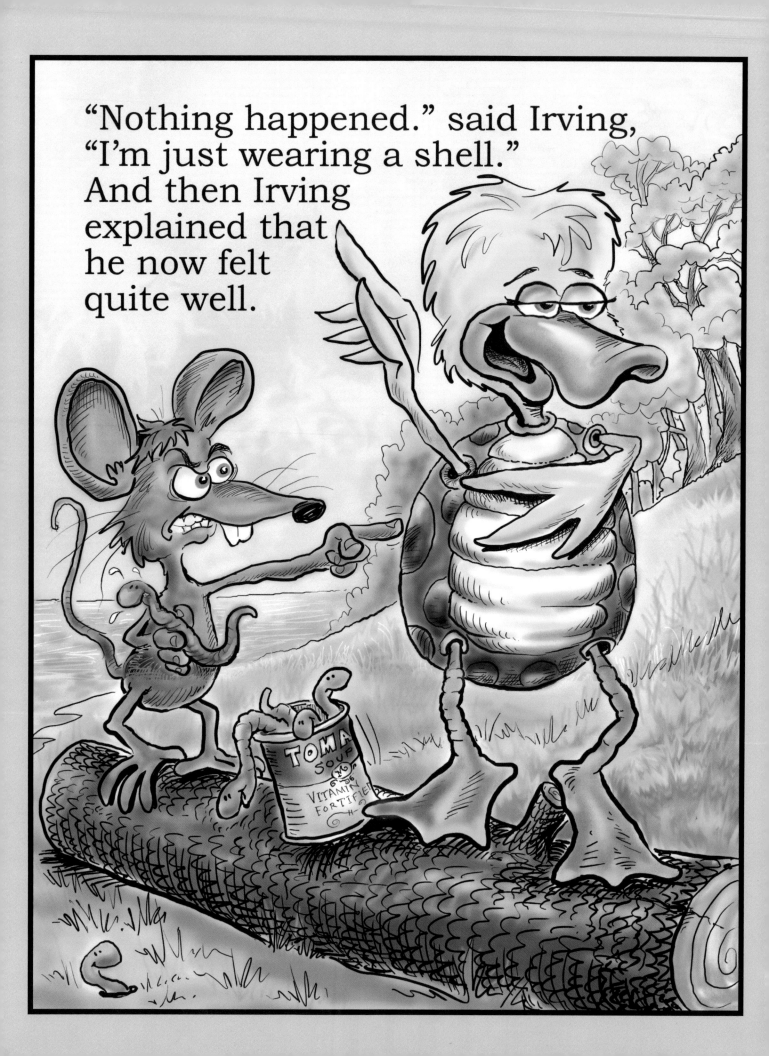

"Nothing happened." said Irving,
"I'm just wearing a shell."
And then Irving
explained that
he now felt
quite well.

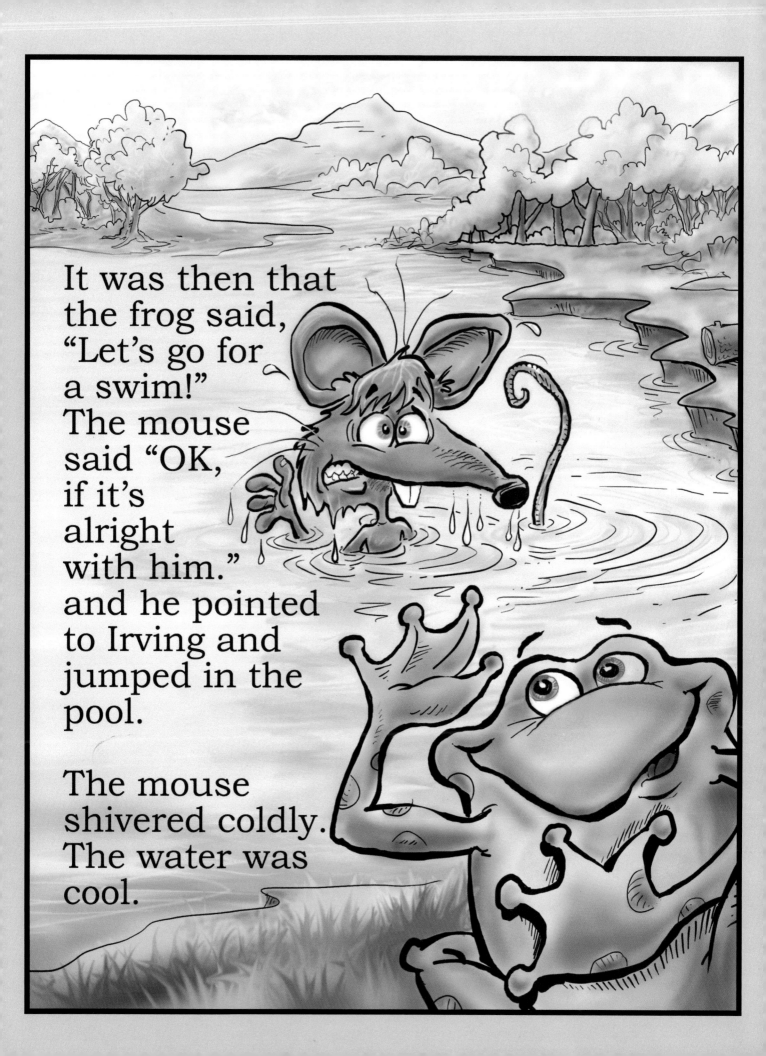

It was then that the frog said, "Let's go for a swim!" The mouse said "OK, if it's alright with him." and he pointed to Irving and jumped in the pool.

The mouse shivered coldly. The water was cool.

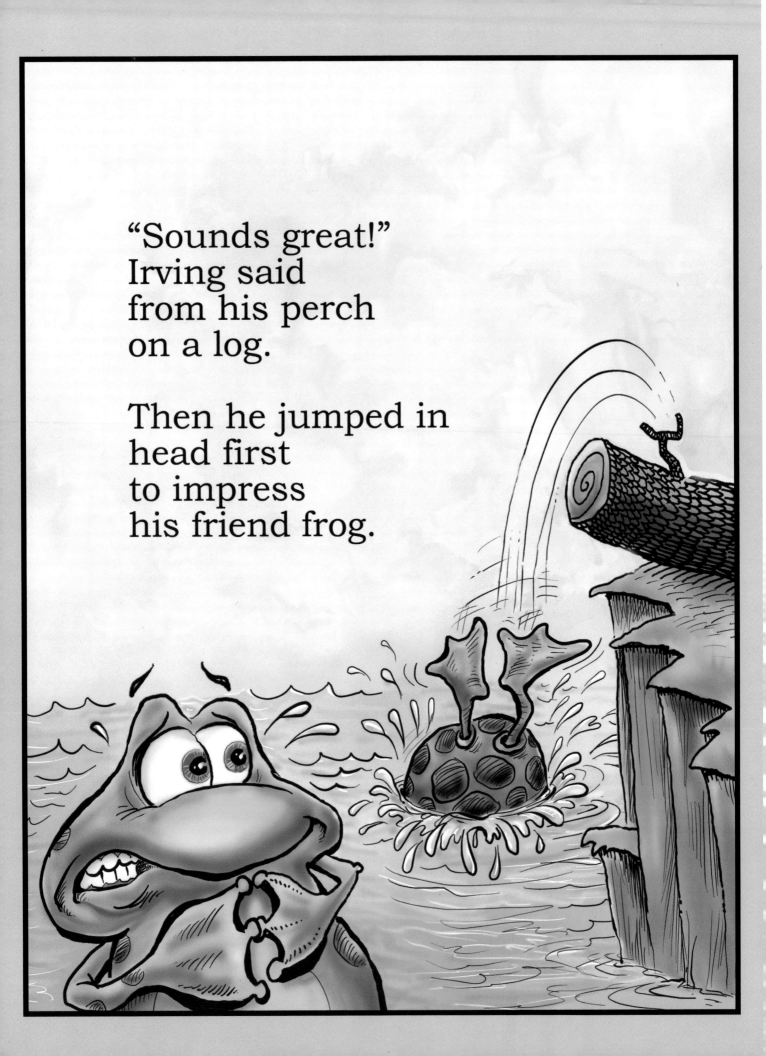

"Sounds great!"
Irving said
from his perch
on a log.

Then he jumped in
head first
to impress
his friend frog.

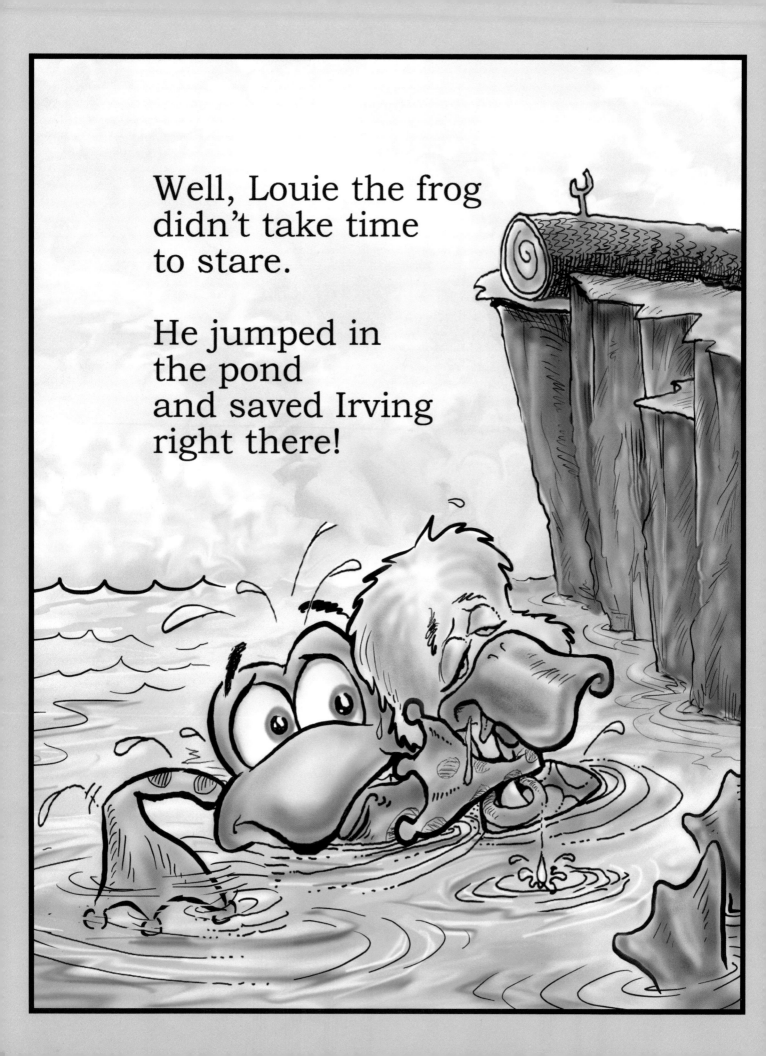

Well, Louie the frog
didn't take time
to stare.

He jumped in
the pond
and saved Irving
right there!

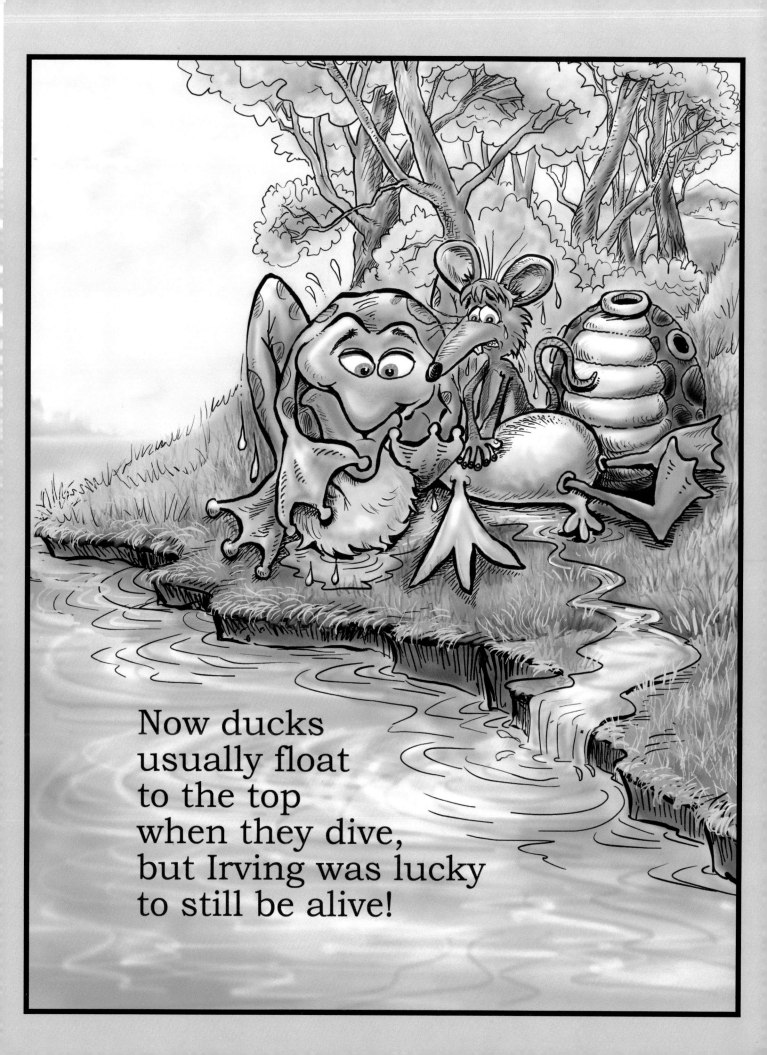

Now ducks
usually float
to the top
when they dive,
but Irving was lucky
to still be alive!

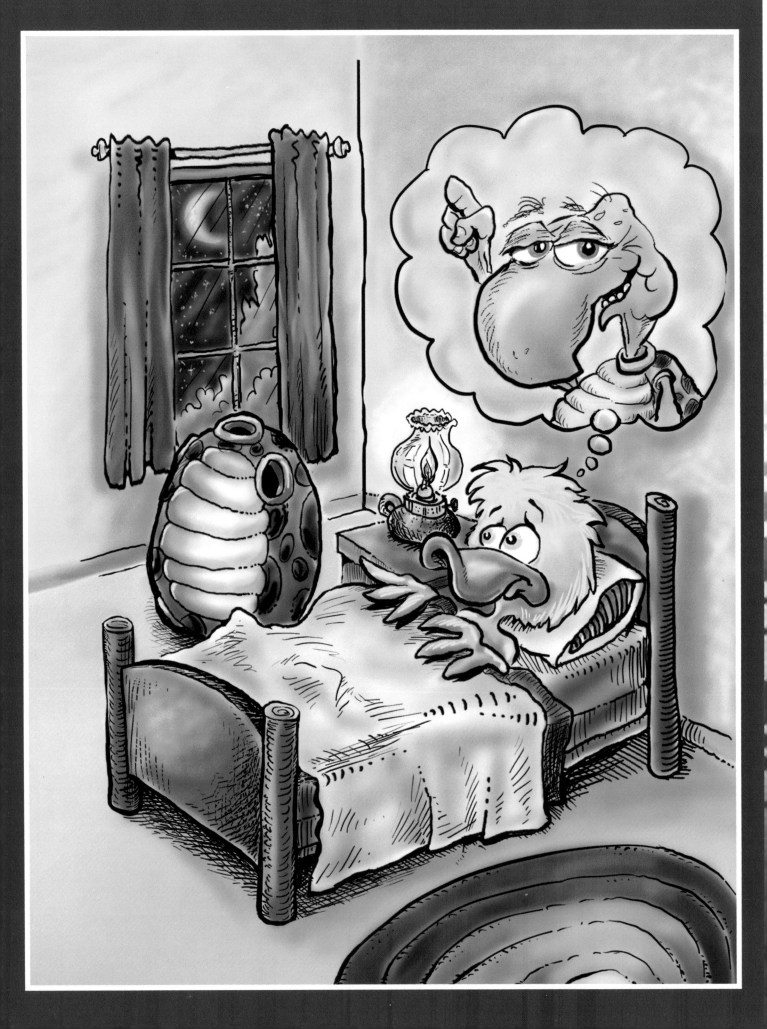

When Irving awoke,
He was home in his bed.
And the first thing he thought of
was what tortoise said...

"If you watch where you're going,
You will know where you've been.

If you don't you will mess up
all over again."

Then Irving remembered what Tortoise was saying.

"You've got to be careful whenever you're playing."

"Remember mistakes and don't do them again...

You must practice, you see... before you can win."

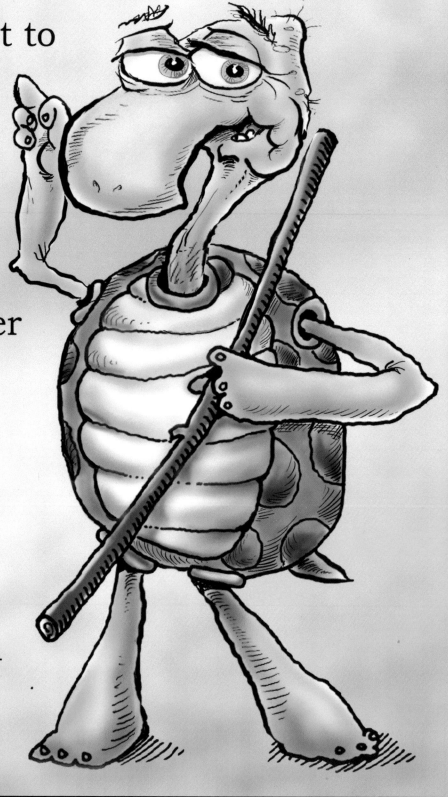

That tortoise shell suit in which Irving took pride wouldn't mean very much if poor Irving had died.

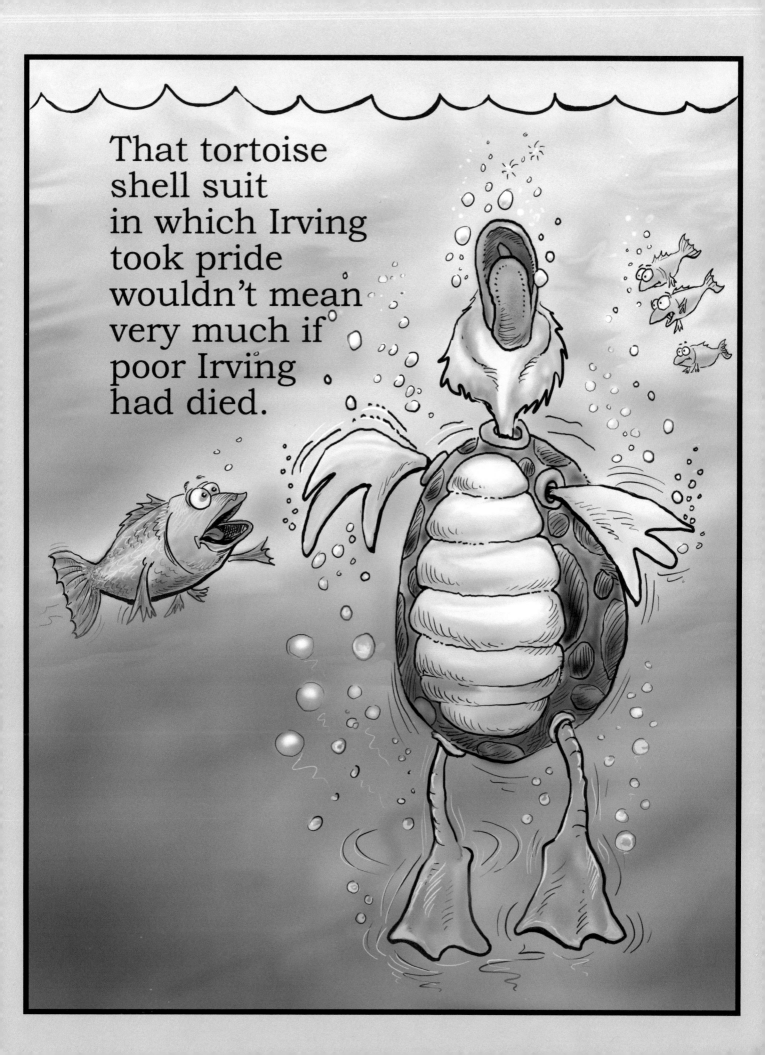

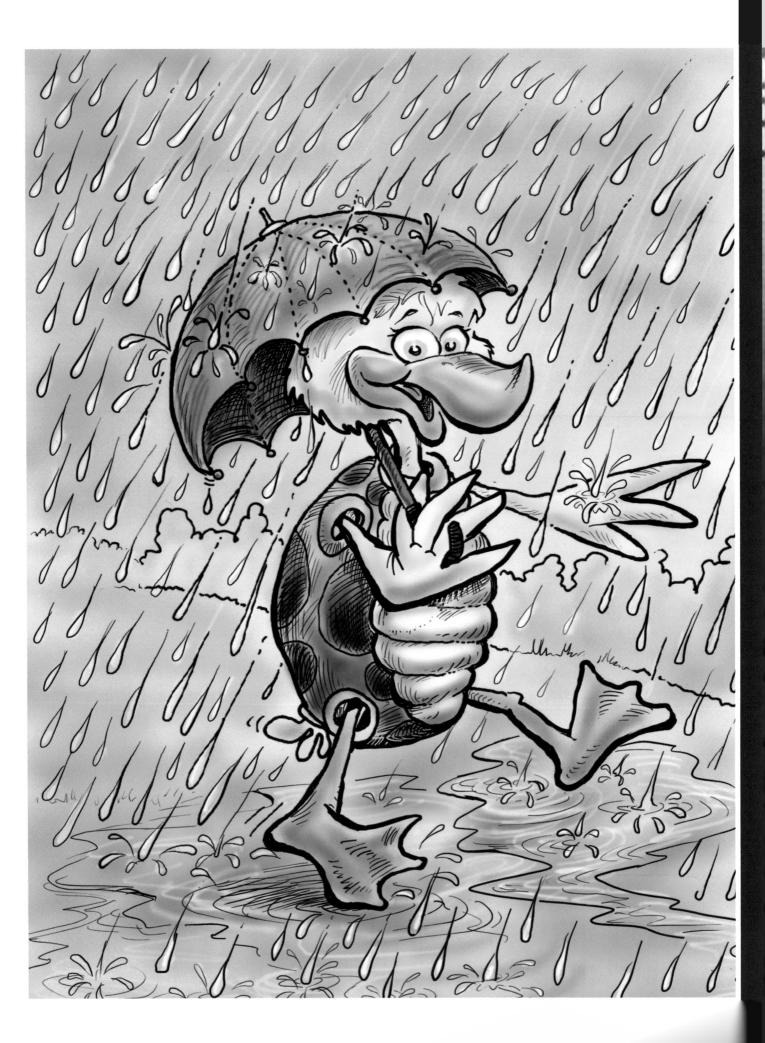

And from that day to this,
Irving never forgot
what the Old Tortoise said,
believe it or not.

And he still wears the shell
on a cold, rainy day.
But he just doesn't
need it...
in quite the same way.

Now Irving believes in
himself...
more and more.

So most of the time...

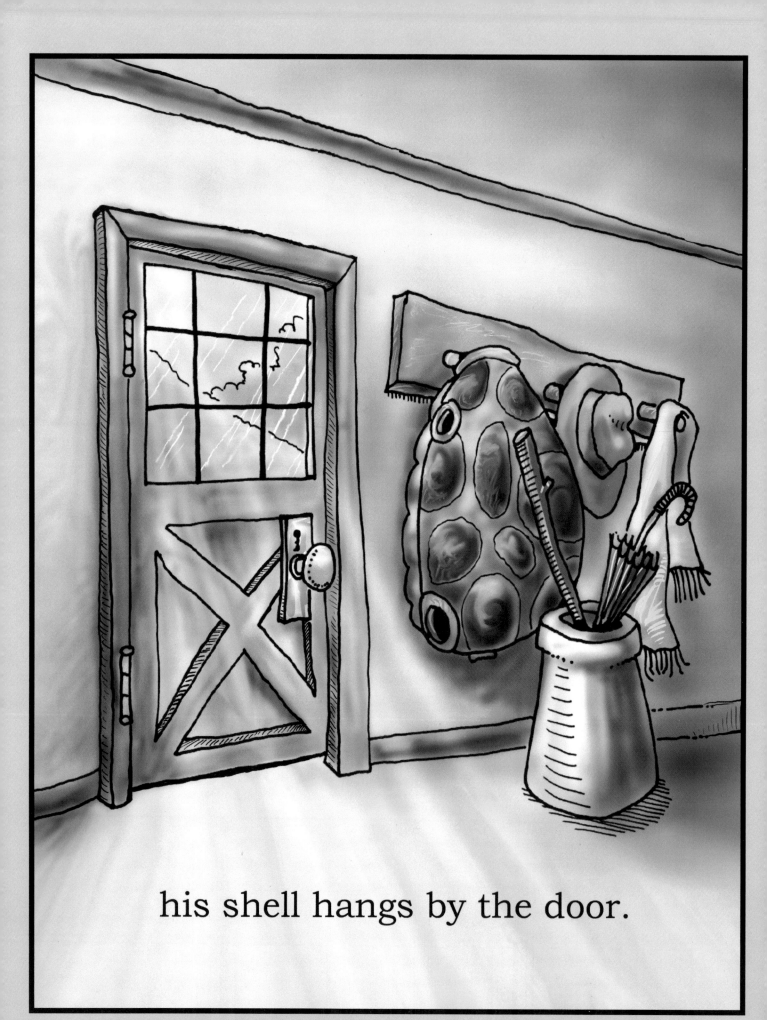

his shell hangs by the door.